Mary Pickford
Queen of the Silent Film Era

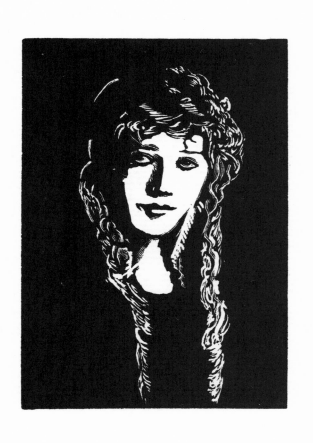

MARY PICKFORD

QUEEN OF THE SILENT FILM ERA

A LIFE IN STILLS

■

■

■

The Porcupine's Quill

1 2 3 · 22 21 20

Published by The Porcupine's Quill, 68 Main Street, PO Box 160,

Erin, Ontario N0B 1T0. http://porcupinesquill.ca

Readied for the press by Stephanie Small. Represented in Canada by Canadian

Manda. Trade orders are available from University of Toronto Press.

Library and Archives Canada Cataloguing in Publication

Title: Mary Pickford, queen of the silent film era : a life in stills /

 George A. Walker.

Names: Walker, George A. (George Alexander), 1960– author, artist.

Description: First edition.

Identifiers: Canadiana 20200194259 | ISBN 9780889844346 (softcover)

Subjects: LCSH: Pickford, Mary, 1892–1979–Pictorial works. | LCSH: Motion

 picture actors and actresses—Canada—Biography—Pictorial works.

 | LCSH: Motion picture actors and actresses—United States—Biography—

 Pictorial works. | LCGFT: Biographies. | LCGFT: Illustrated works.

Classification: LCC PN2308.P53 W35 2020 | DDC 791.4302/8092—dc23

We acknowledge the support of the Ontario Arts Council and the Canada

Council for the Arts for our publishing program. The financial support of the

Government of Canada through the Canada Book Fund is also acknowledged.

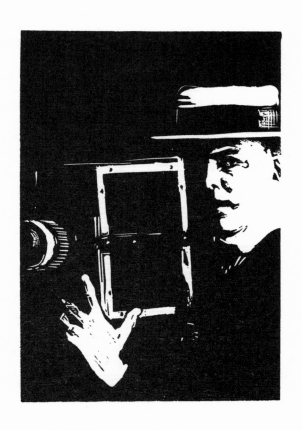

FOREWORD

Mary Pickford was a multifaceted pioneer of early cinema—a gifted performer, a creative producer, a studio owner and a distributor—who helped shape the film industry as we know it today. 'No role she can play on the screen is as great as the role she plays in the motion picture industry,' said *Photoplay* in 1924. 'Mary Pickford the actress is completely overshadowed by Mary Pickford the individual.'

Born in Toronto in 1892, her real name was Gladys Smith. She was five when her father died. A boarder her mother took in suggested the child take to the stage to help make ends meet. While her mother and younger brother and sister also worked in the theatre, 'Little Gladys' quickly gained a following. She taught herself to read on the trains that took her to the next job, and she developed a strong belief in herself, incredible discipline and a commitment to working hard to support her family. She was persistent in her appeals to Broadway impresario David Belasco, who finally cast her in the stage production of *The Warrens of Virginia* in 1907. Together they reviewed her family tree and came up with the stage name Mary Pickford. When she told her mother about her new contract and her new name, her mother's faith in Mary was such that the entire family changed their last name to Pickford as well. This was a burden and responsibility Mary carried throughout her life, but without resentment.

When Pickford began making movies in 1909, films were

an idea one week, in front of the cameras the next, and in theatres within a month. Hundreds of actors attempted to make their mark in those early days, but audiences discerned something special in Mary Pickford, and she rose steadily to fame at a time when there was no career path to follow. Mary became known as 'the girl with the curls', and when people clamoured to learn more about her, fan magazines were created. In 1912, the very first issue of *Photoplay* featured Mary dressed as her character in *Little Red Riding Hood*.

After two years under the direction of D.W. Griffith, Mary went on to work with Cecil B. DeMille, Allan Dwan, James Kirkwood, Marshall Neilan, Sidney Franklin, Maurice Tourneur and Ernst Lubitsch. Her career was buoyed by fellow professionals who were also friends, including the cinematographers Billy Bitzer and Charles Rosher as well as the screenwriter Frances Marion. First in one- and two-reel films and then in features, Mary played a wide variety of characters. She naturally radiated a quiet confidence as she played girls with a backbone, a belief in justice and a strong sense of community.

Between 1912 and 1919, Mary Pickford jumped between a variety of studios, increasing her paycheque astronomically each time (from ten dollars a week to a million dollars a year) until she became the highest paid actor in the world. Then she risked it all by joining with Douglas Fairbanks, D.W. Griffith and Charlie Chaplin to form their own distribution company, United Artists. The reaction from studio bosses can be summed up by the oft-repeated line, 'The inmates have taken over the asylum.' It was not a smooth road, but Pickford and the others gained what was most important to them—control over their own work. Mary would risk her career again the following year when she made the decision that, instead of being 'America's sweetheart', she wanted 'to be one man's

sweetheart'. Though stars were told they could not be divorced and remain big box office, Mary divorced Owen Moore and married Douglas Fairbanks in 1920. But instead of becoming pariahs, Mary and Douglas experienced soaring popularity, and their union was greeted as a storybook marriage. They were hailed as Hollywood royalty and reigned from their Beverly Hills home, dubbed Pickfair, until their divorce in 1936.

Mary made her final film as an actress, *Secrets*, in 1933, but by then she was already working behind the camera as a producer and as a board member of United Artists. She also wrote a novel and several inspirational booklets, hosted the radio program *Parties at Pickfair*, and continued to welcome friends for visits. And in 1937, she married Buddy Rogers, with whom she had co-starred in *My Best Girl*.

One of the original thirty-six founders of the Academy of Motion Picture Arts and Sciences, Pickford also became a founder of the Society of Independent Motion Picture Producers in 1941. She stayed active in film production until she sold her interest in United Artists in the mid-1950s — the last of the original founders to do so. By then she had established herself as one of the most successful actresses of all time, and had won an Academy Award for her first 'talkie', *Coquette*. She went on to receive an honorary Oscar for her contribution to motion pictures in 1976, three years before her death. Mary Pickford was also an early leader in the film preservation movement and ardently supported the creation of a museum devoted to the art of moviemaking.

Philanthropy was also a hallmark of Mary Pickford's long life. When she travelled the country in 1918 selling WWI bonds to thousands of fans, she realized how she could use her influence and popularity to inspire others to give. She would go on to leverage that power in a variety of endeavours.

She was a hands-on supporter of the creative community. She never forgot the poverty of her early years, and put empty pots around her sets to collect change for the needy. In 1921, she became the founder and first vice-president of the Motion Picture Relief Fund and spearheaded the Payroll Pledge Program, which financed the Relief Fund by deducting one half of one percent from the salaries of those making over two hundred dollars a week. In the early 1940s, Mary was there with shovel in hand to break ground for what would be the Motion Picture & Television Country House and Hospital. Now called the Motion Picture & Television Fund, it is still serving the needs of the creative community.

It is estimated that 80 percent of all silent films are 'lost'—a euphemism for films that were sold for scrap, dumped into the ocean, tossed to make room in vaults, or left to rot on the shelf—yet most of Mary Pickford's films survive. Still, many are in need of preservation and restoration, and the Mary Pickford Foundation is actively working with archives worldwide to do just that. They also continue her philanthropic work with the Motion Picture Television Fund and dozens of educational institutions.

—*Cari Beauchamp*

CARI BEAUCHAMP, the Mary Pickford Foundation's Resident Scholar, is the author of *Without Lying Down: Frances Marion and the Powerful Women of Early Hollywood* and five other books on film history. She has written two documentary films and has contributed to *Vanity Fair, Architectural Digest, Variety, The Hollywood Reporter, The New York Times* and more. Her work has been nominated for an Emmy and a Writers' Guild Award, and she is the only person to be twice named an Academy of Motion Picture Arts and Sciences Scholar.

MARY PICKFORD

A LIFE IN PICTURES

In the early twentieth century, a new form of spectacle known as the `flicker' or `flick' revolutionized popular entertainment. These silent movies quickly gained worldwide popularity. As well as providing cheap entertainment, they were polylingual, and could be easily shown anywhere in the world just by translating a few frames (called intertitles) that described the action on the screen.

The first filmmakers had at their disposal little more than imagination and a desire to create narratives that would entertain and astonish audiences. Actors and directors learned their craft as they went along; theirs was a new and magical technology that was largely experimental. These pioneers wanted to make picture plays that were free from the limits of the stage and that exploited the powerful illusions of stop-action and visual perspective.

One person in particular captured the imaginations of the audiences who avidly consumed these motion pictures: a tough, self-confident teenager with long golden curls who portrayed characters who were fragile and innocent, yet morally strong and possessed of a strong sense of social justice. She was born Gladys Smith, but she would soon be known to the world as Mary Pickford.

I chose Mary Pickford as the subject for this book because of my interest in Canadian and Canadian-born artists and, more specifically, in Pickford's influence on early

filmmaking. I challenged myself to create a series of wood engravings that told the story of her life in a printed, visual sequential narrative, interspersed with intertitles of the sort that would have been used on screen. My desire was to echo the form of silent film as the reader turns the pages. The black-and-white wood engravings remind me of the monochromatic medium of the movies of the silent film era.

With this Mary Pickford biography, I have, of necessity, removed motion from her story. What communicated narrative to her film audience—and what interests me—are her facial expressions, her body language and her playful use of movement. These are the qualities I wanted to capture in my wood engravings. Although I engraved 96 blocks to tell her story, I ultimately chose only 87 images for the book, one for each year of her life. The engravings I chose to include in this collection were the ones that best captured her spirit and her ability to communicate strong emotion to rapt audiences the world over.

I used many resources as I set out to explore the world of Mary Pickford, including original artifacts, analog photos, DVD and 8mm films and, of course, books about her life and career. Inevitably, some aspects of Pickford's lived experience are missing, as are references to many of her early films, but what remains gives, I hope, a faithful representation of who Mary Pickford was and what she accomplished.

All the engravings in this book, except for three, are in what we would call portrait mode. The proportions of the human body are best suited to such an orientation, and, conventionally speaking, the book object itself tends to be taller than it is wide. This format allows for a visually appealing placement of the image on the similarly shaped page.

Landscape-oriented images give the eye a greater viewing panorama, and modern audiences consider a wide

rectangle to be the ideal shape for movies. They are best suited to scenes with more than two people, or to show action and interaction with the environment. The three landscape-oriented engravings in this book, representing Pickford's early career as a stage actress, contain a multitude of people and require a wider frame in order to convey important contextual clues necessary to 'read' the images.

Marshall McLuhan[1] posited that different technologies can affect our perception of a given message in ways in which we are often not even aware. The cell phone has changed how motion and static images are created, distributed and understood. Many people view social media, watch videos and take photographs in portrait orientation with their smartphone because they can most comfortably hold it as they would hold a book.

I wanted to explore how technology can change our perceptions and reframe our experiences. What might it have been like if the early cinematographers had shot their film as portrait-aligned images? Would that have changed how narratives are framed? Would it have altered our understanding of moving pictures? I think it would have. All artists, including wordless novelists, must consider whether the orientation of an image influences the viewer's 'reading' of it. As James Gleick wrote[2], 'Every new medium transforms the nature of human thought. In the long run, history is the story of information becoming aware of itself.' Our cell phone culture may not have changed our appreciation of the power of motion

1. McLuhan, Eric, and Frank Zingrone. *Essential McLuhan* (Toronto: House of Anansi, 1995).

2. Gleick, James. *The Information: A History, a Theory, a Flood* (New York: Pantheon, 2011).

pictures, but it has changed how we process, focus and extrapolate meaning in the images that we see.

Though my stated purpose has been to pay homage to the aesthetic of the moving picture, this book differs in two major respects from the silent films of old. When we think of silent films, we think of images rendered in shades of grey, and this mental connection is one of the reasons I printed my engravings in black and white. In fact, many of the early silent movies were tinted—blue tints were used to indicate scenes at night while amber was used to suggest scenes during the day. Colour contributed to the viewer's 'reading' of time. Similarly, books are often read in silence, but contrary to their name, silent films were never silent. Sometimes actors were hired to read the titles on the screen or to add their own dialogue to scenes. Often a pianist or organist, and occasionally even a small orchestra, provided the music.

Despite these departures from the traditional silent film format, this book stays true to its desire to celebrate Mary Pickford's life in a way that befits her experience and accomplishments. Relief printing, the process by which wood engravings are printed on paper, is one of the oldest forms of graphic reproduction. You might well ask why anyone would bother making prints from wood engravings in the age of digital reproduction. Why not just mass-produce the images using some other process, such as photocopying or offset lithography? The answer—and the value of woodcuts themselves—is that there is an important authenticity in making prints that my hands have carved directly from wood. The texture of the paper, the smell of ink on the page, the feel of the impression and the book object itself, all have an intrinsic visual and tactile value. This value is lost in the infinite reproducibility of the internet.

I'm always looking for evidence of the human hand in

artworks. I like the notion that I've taken wood from a tree and made it tell a story. You're holding something I made with my hands. I carved the blocks and I inked them and pressed them onto the paper. I left part of myself there.

This book ends with my engraving of the Venus de Milo beside a Mary Pickford quotation. It seems to me that the sculpture of the Venus de Milo, which is believed to depict Aphrodite, the Greek goddess of love and beauty, can also represent how our notion of beauty changes with time. Modern eyes might consider the statue beautiful—despite the fact that the artist created the sculpture arms intact and in living colour. Similarly, Pickford's words demonstrate that she prized the silent film precisely because of its lack of sound.

To her, adding sound to the movies could be considered a garish addition that undermined the dignity and appeal of the film. From a postmodern perspective, we admire the beauty of the sculpture sans arms—but this was not what the artist intended. There is something to be gained when new conceptions of art supersede old ones, but there is also something lost.

—George A. Walker

GEORGE A. WALKER holds an MA in Communication and Culture from Ryerson and York universities. He is an associate professor at OCAD University where he teaches book-related arts in the Printmaking program. He is the author of the popular how-to book, *The Woodcut Artists' Handbook*, now in its second revised edition (Firefly Books, 2010). He is recognized for *Written in Wood*, an anthology of his wordless narratives (Firefly Books, 2014) and for *Graphic Witness* (Firefly Books, 2007), his art history book on wordless novels.

MARY PICKFORD

QUEEN OF THE SILENT FILM ERA

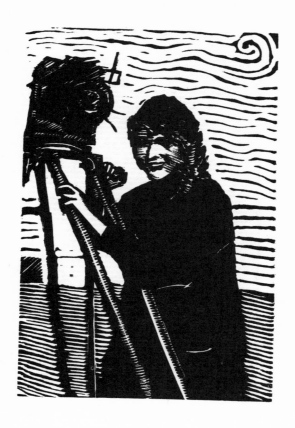

Gladys Smith—who later
takes the name Mary
Pickford—is born April 8,
1892, in Toronto.

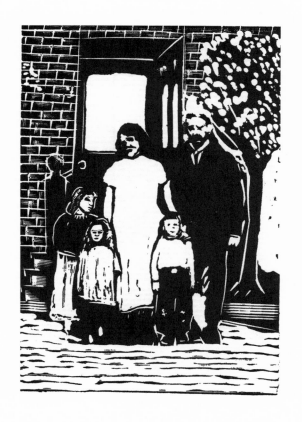

Gladys's father, John Smith, dies on February 11, 1898, of a cerebral hemorrhage he sustained in a workplace accident.

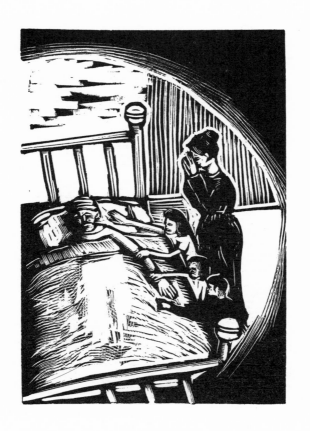

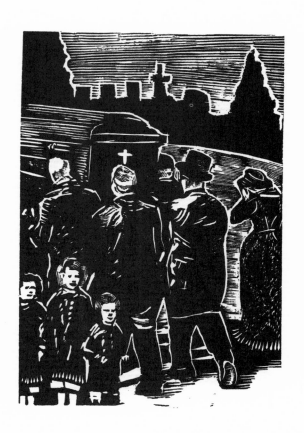

The untimely death of
Gladys's beloved father
puts the family in a
precarious financial
position.

■

How will they make ends
meet?

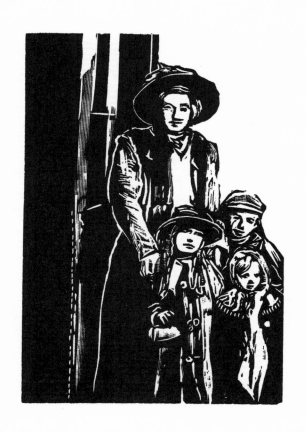

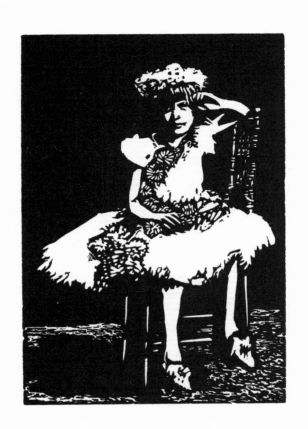

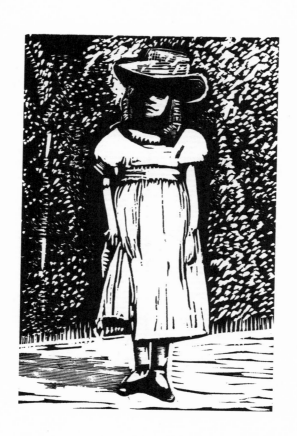

Gladys is five years old
when her father dies.

A boarder taken in by her
mother suggests the child
perform onstage at the
local theatre to earn
money.

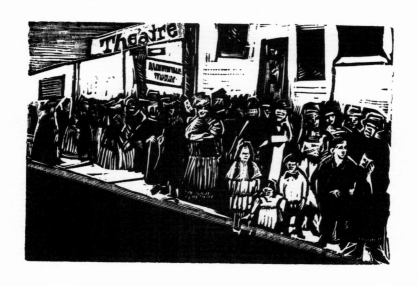

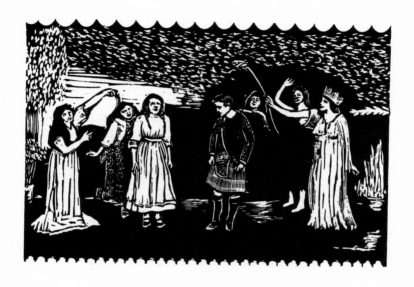

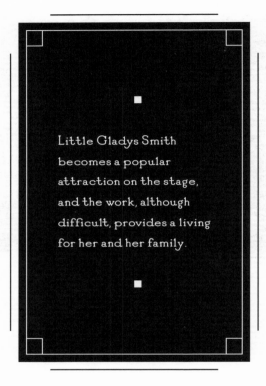

Little Gladys Smith becomes a popular attraction on the stage, and the work, although difficult, provides a living for her and her family.

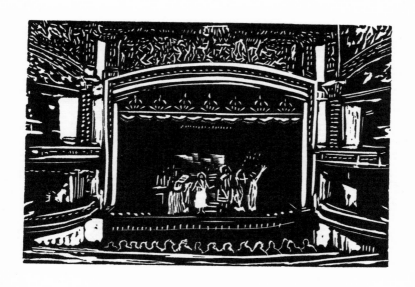

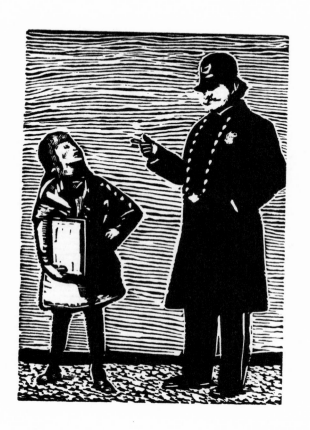

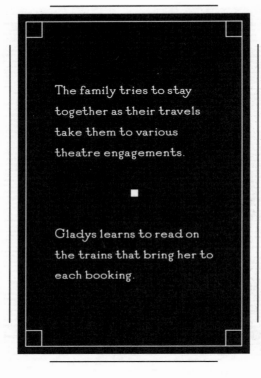

The family tries to stay
together as their travels
take them to various
theatre engagements.

Gladys learns to read on
the trains that bring her to
each booking.

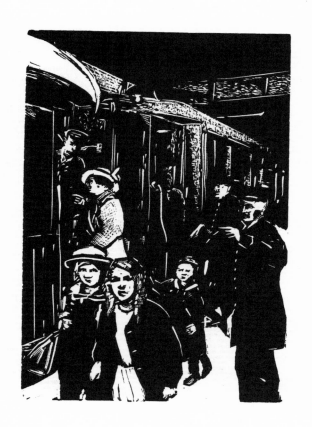

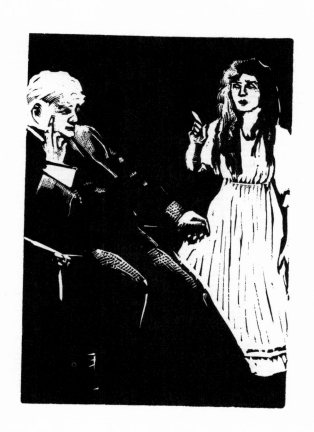

Broadway producer David Belasco suggests Gladys Smith change her name to Mary Pickford.

■

The stage name is a play on her middle name, Marie, and her grandfather's name, John Pickford Hennessey.

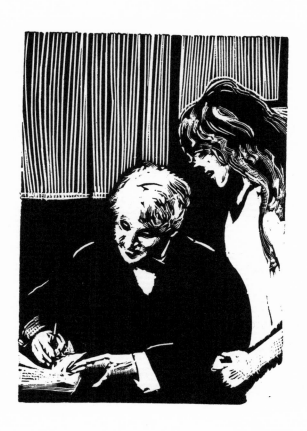

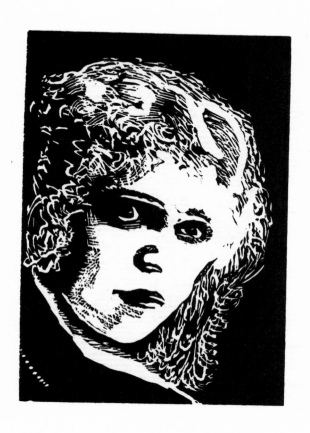

At the age of 17, Mary
Pickford makes her screen
debut.

■

Her cameraman for most
of her films, Billy Bitzer,
goes on to become a
pioneer in the field of
matte photography and
experimental lighting
techniques.

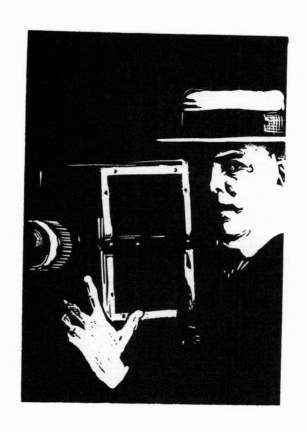

Against her mother's
wishes, Mary secretly
marries fellow Biograph
Company actor Owen
Moore on January 7, 1911.

■

The marriage would be
an unhappy one.

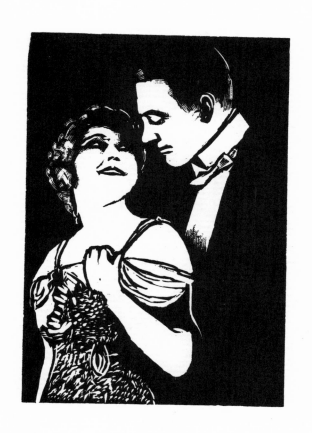

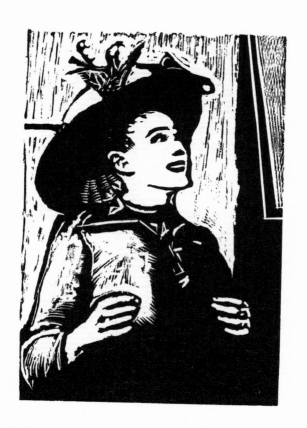

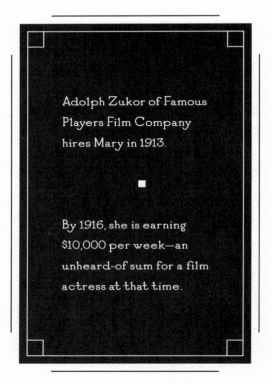

Adolph Zukor of Famous
Players Film Company
hires Mary in 1913.

■

By 1916, she is earning
$10,000 per week—an
unheard-of sum for a film
actress at that time.

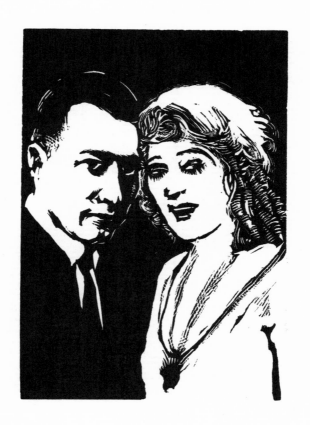

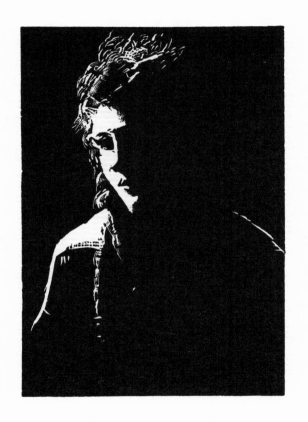

Moving Picture World
magazine praises Mary's
performance as Queen
Anna Victoria of
Herzegovina as being 'of
rare quality'.

■

The media refer to her as
'The Queen of the Movies'.

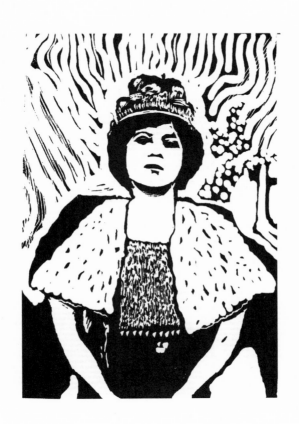

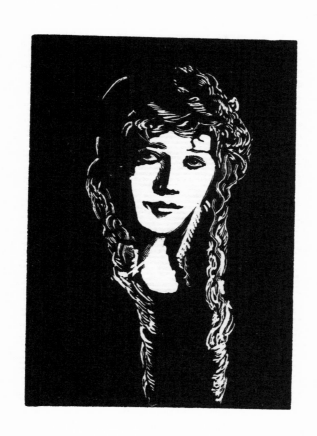

Tess of the Storm Country is released in 1914 to rave reviews.

■

Variety calls it `another feather in [Pickford's] movie crown`.

■

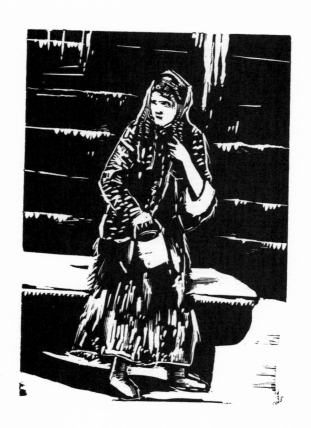

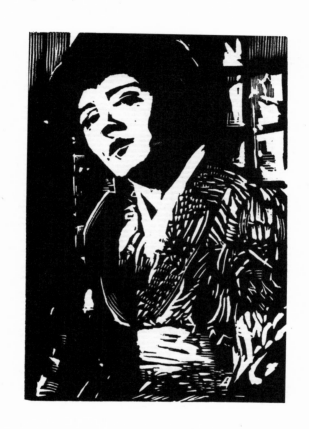

Mary's mother, Charlotte,
acts as Mary's agent and
manager.

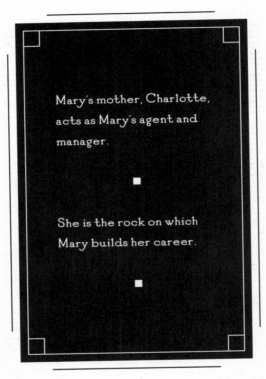

She is the rock on which
Mary builds her career.

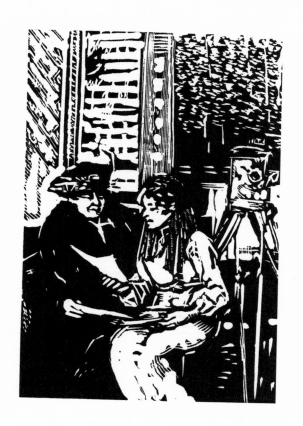

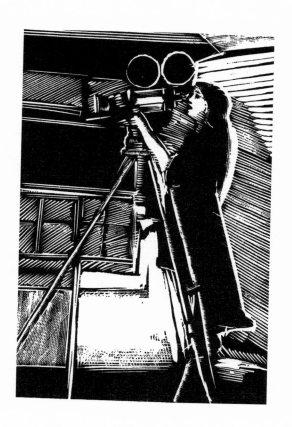

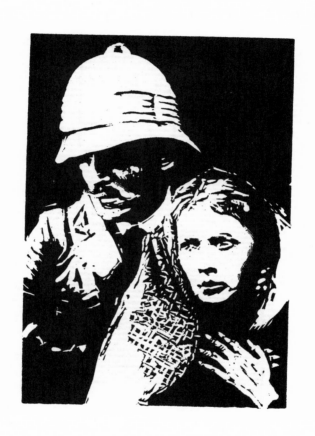

Mary becomes more than
just an actress.

■

She is an innovator who
helps shape the
burgeoning film industry
by working behind the
scenes as a producer,
studio owner and
distributor.

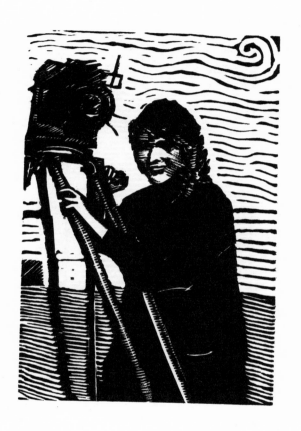

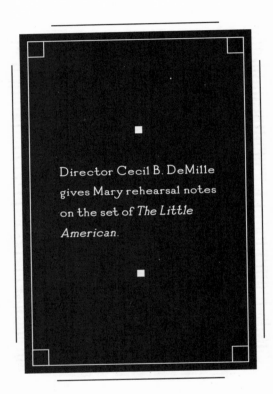

Director Cecil B. DeMille gives Mary rehearsal notes on the set of *The Little American*.

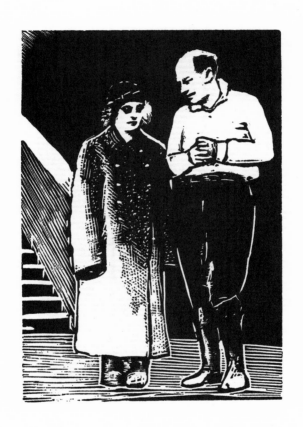

An accomplished dramatic
and comic actress, Mary
Pickford is not afraid to
temper her comedic roles
with sad, poignant
moments.

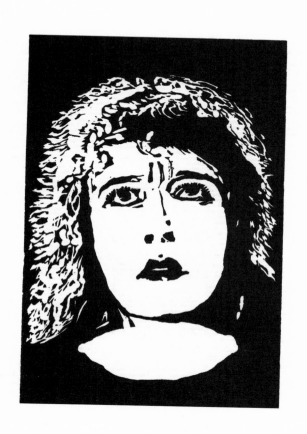

Mary is keen to experiment with different roles and to broaden her acting skills.

■

In 1918, she makes cinematic history with a dual role in the film *Stella Maris*, starring as both the title character and an orphaned servant.

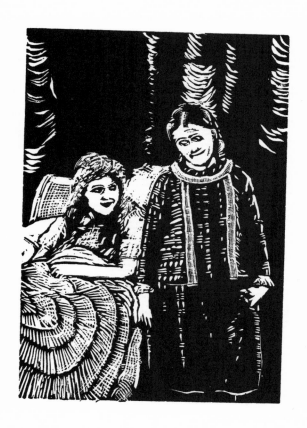

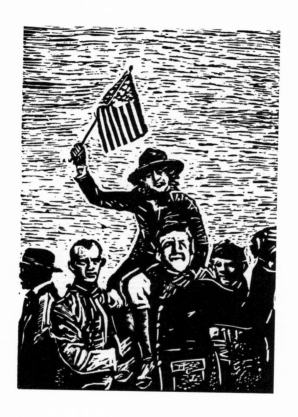

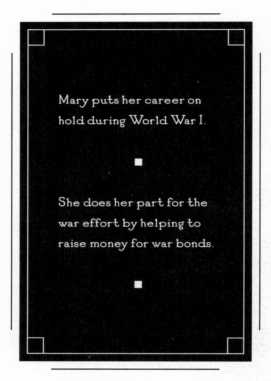

Mary puts her career on hold during World War I.

She does her part for the war effort by helping to raise money for war bonds.

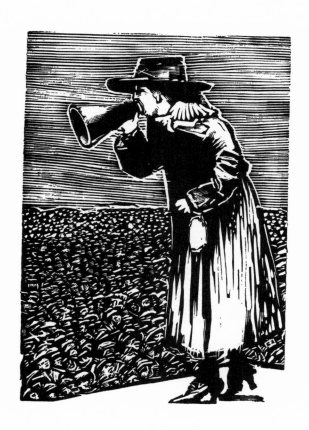

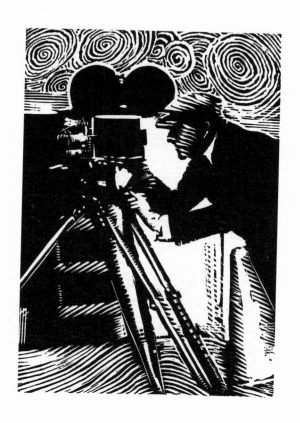

Mary forms The Mary
Pickford Company in
order to produce her own
films and to control the
hiring of directors and
screenwriters.

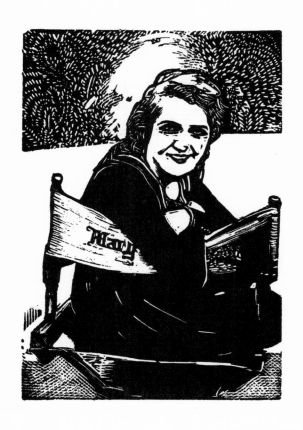

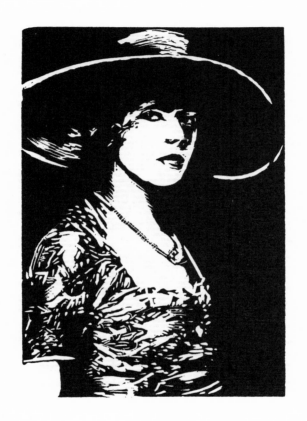

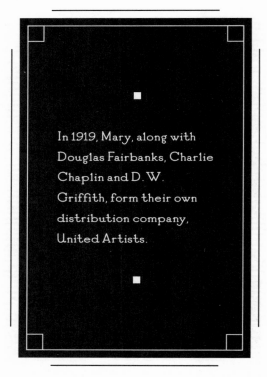

In 1919, Mary, along with
Douglas Fairbanks, Charlie
Chaplin and D. W.
Griffith, form their own
distribution company,
United Artists.

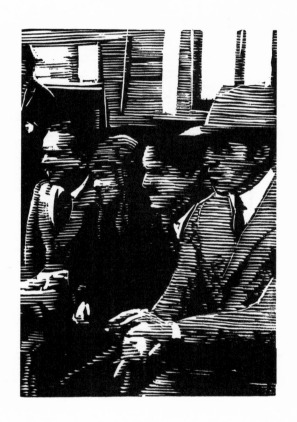

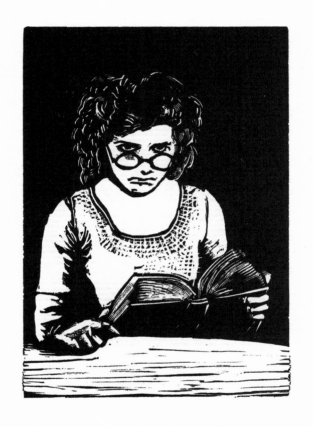

Mary divorces her first husband, Owen Moore, paving the way for her marriage to Douglas Fairbanks.

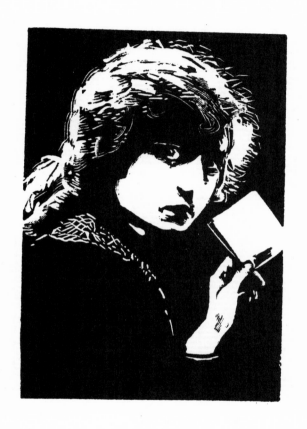

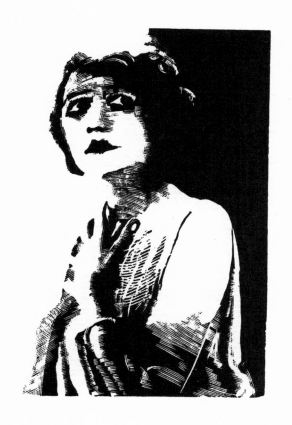

Mary Pickford marries
Douglas Fairbanks on
March 28, 1920.

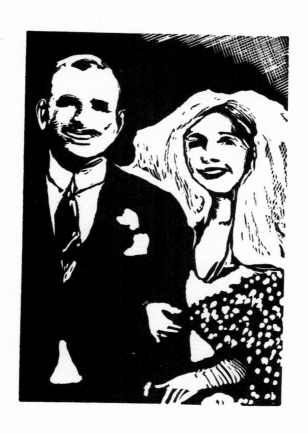

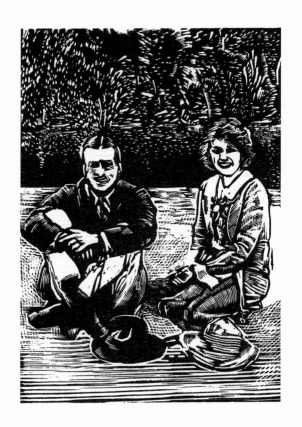

The newlyweds set out on
a European honeymoon.

■

They are surrounded by
fans everywhere they go.

■

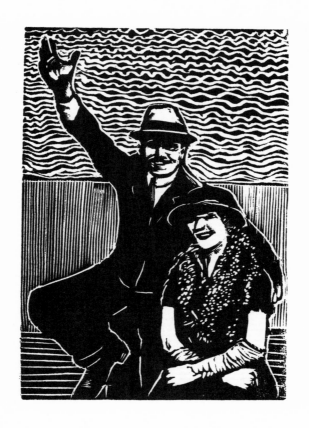

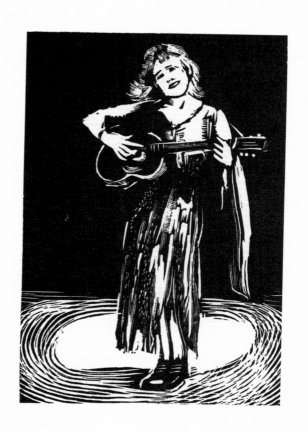

Frances Marion is one of Mary's closest friends, and the two make many films together, including *Pollyanna* and *The Love Light*.

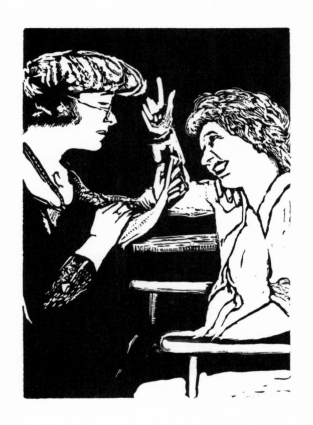

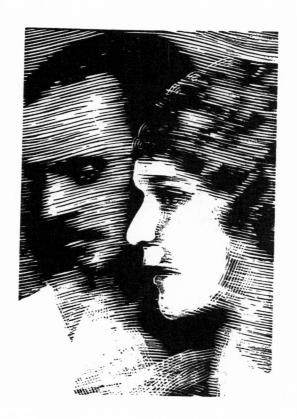

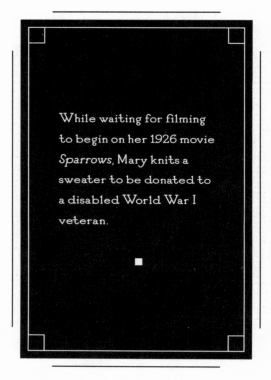

While waiting for filming to begin on her 1926 movie *Sparrows,* Mary knits a sweater to be donated to a disabled World War I veteran.

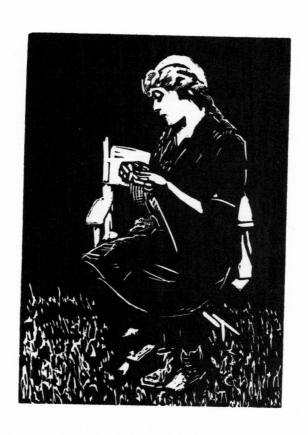

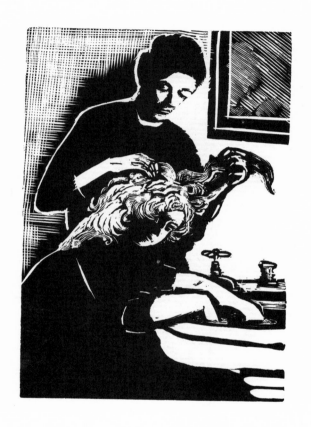

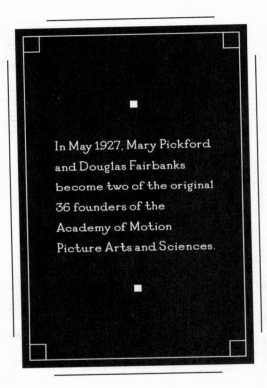

In May 1927, Mary Pickford
and Douglas Fairbanks
become two of the original
36 founders of the
Academy of Motion
Picture Arts and Sciences.

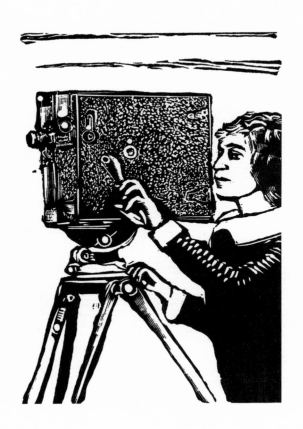

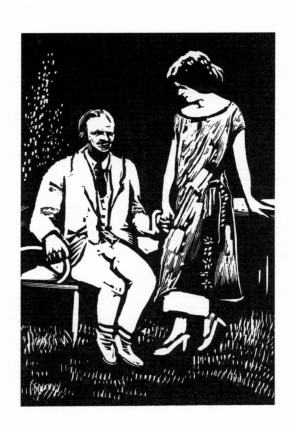

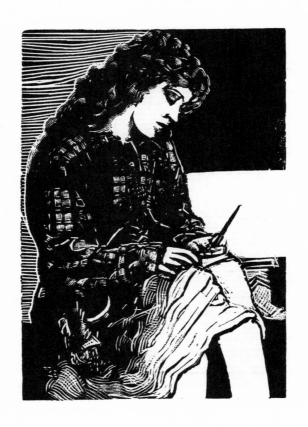

A rowdy Mary delights
audiences by playing a
tomboy in the 1926 film
Little Annie Rooney.

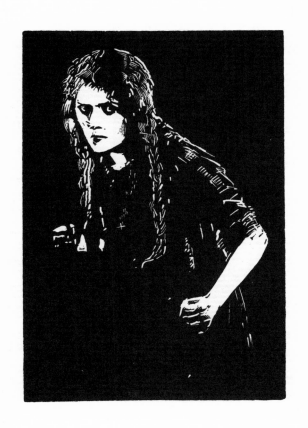

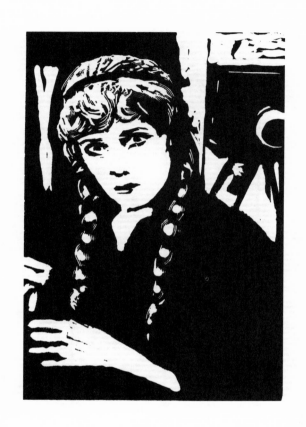

1927 marks Mary's final silent film, *My Best Girl*.

■

Her co-star for the picture is 'America's Boy Friend' Charles 'Buddy' Rogers.

■

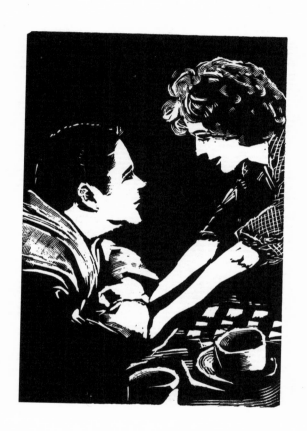

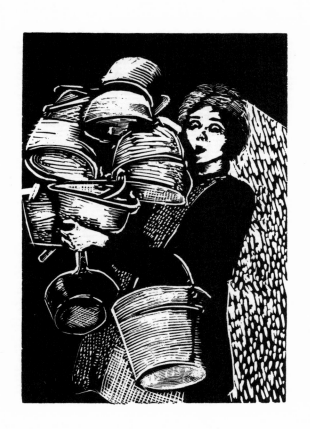

On March 21, 1928,
Mary loses her mother,
Charlotte Smith, to
breast cancer.

■

Mary is shattered.

■

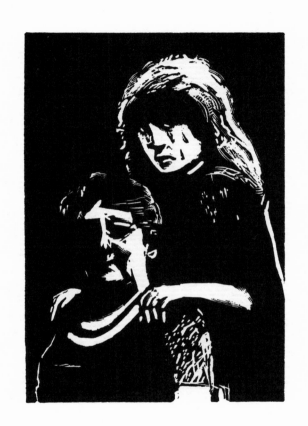

Mary cuts her trademark curls and adopts a short bob hairstyle.

■

Her new style makes the front page of the *New York Times*.

■

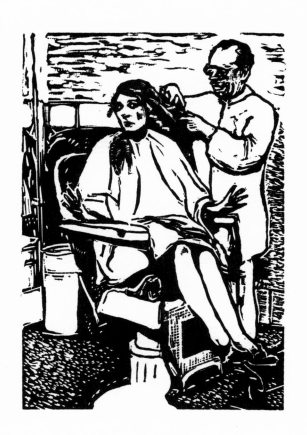

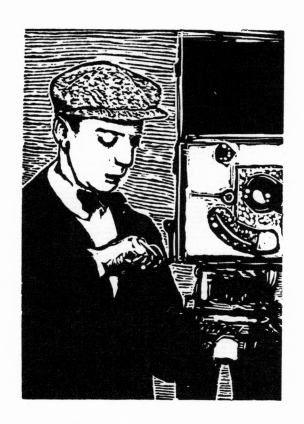

Mary wins the Academy Award for Best Actress on April 3, 1930, for her performance in the talkie film *Coquette*.

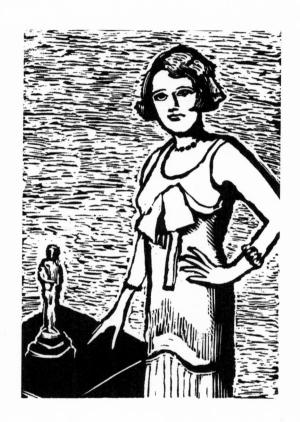

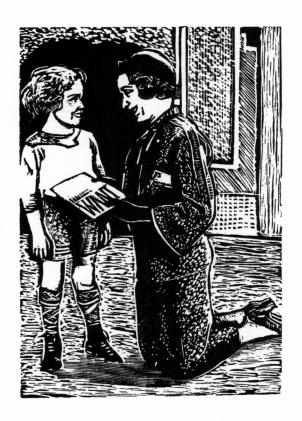

Worried about her future,
Mary sometimes consults
with the spirit world.

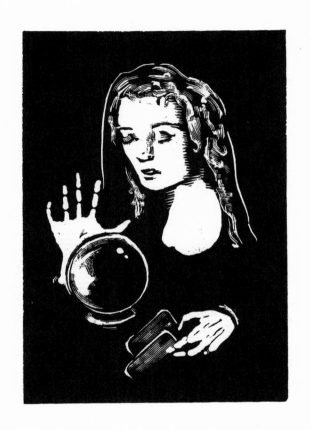

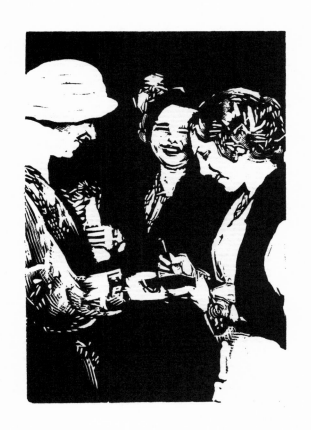

Mary makes her second-
to-last film, a talkie called
Kiki.

◼

It receives a lukewarm
reception at the box
office.

◼

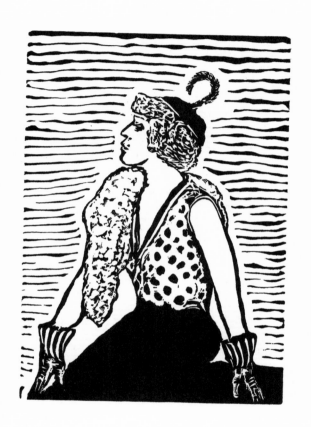

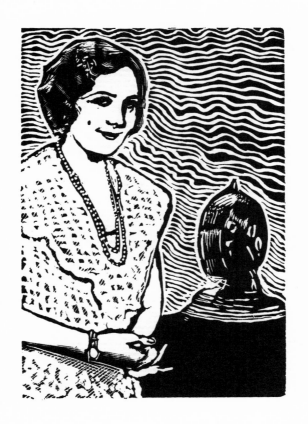

In 1933, Mary Pickford and Walt Disney discuss making an animated and live action *Alice in Wonderland*, with Mary to star in the title role.

■

The film is never made.

■

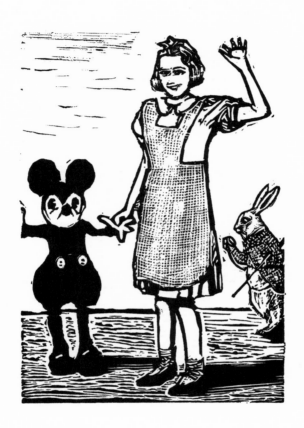

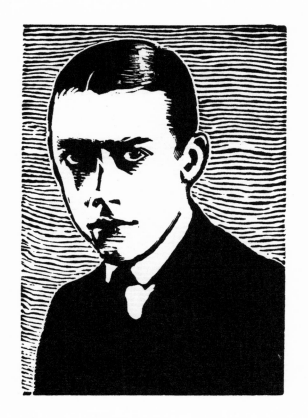

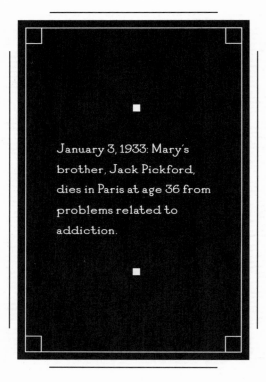

January 3, 1933: Mary's brother, Jack Pickford, dies in Paris at age 36 from problems related to addiction.

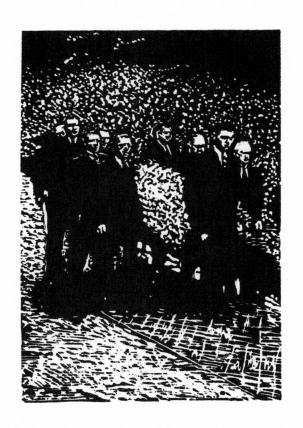

■

Mary writes several books
including a novel, *The
Demi-Widow* (1935), and
her autobiography,
Sunshine and Shadow (1955).

■

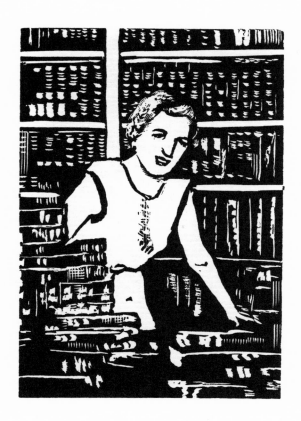

1936 is a difficult year.

Mary and Douglas
Fairbanks divorce after his
romance with Lady Sylvia
Ashley becomes public.

On December 9, Mary's
sister, Lottie Pickford,
dies of a heart attack.

■

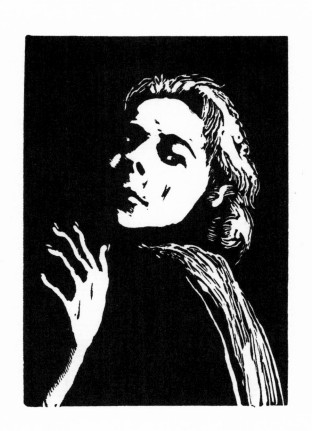

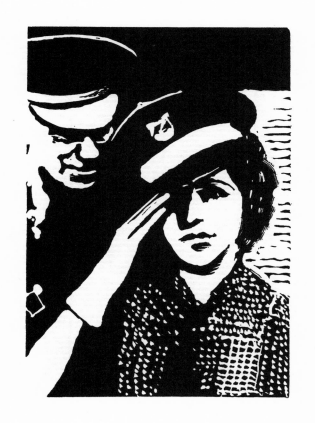

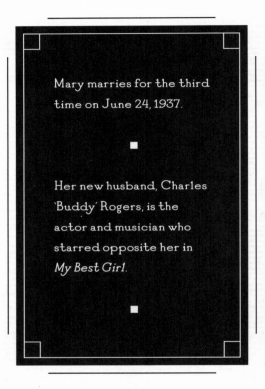

Mary marries for the third time on June 24, 1937.

■

Her new husband, Charles 'Buddy' Rogers, is the actor and musician who starred opposite her in *My Best Girl*.

■

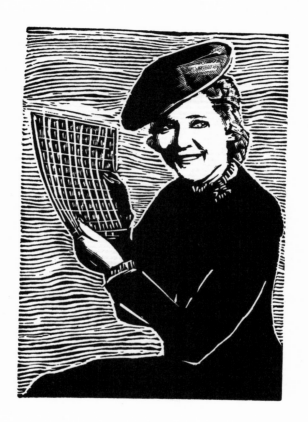

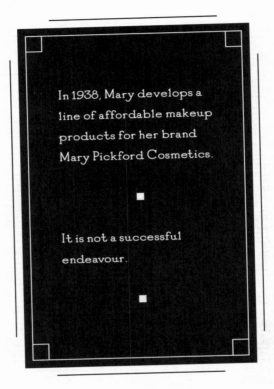

In 1938, Mary develops a
line of affordable makeup
products for her brand
Mary Pickford Cosmetics.

It is not a successful
endeavour.

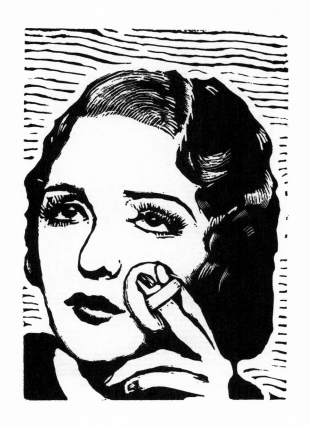

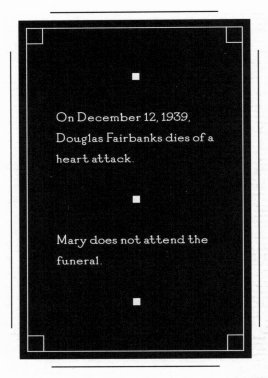

On December 12, 1939,
Douglas Fairbanks dies of a
heart attack.

Mary does not attend the
funeral.

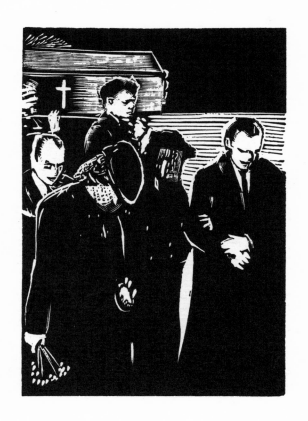

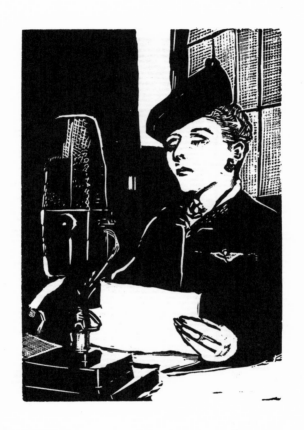

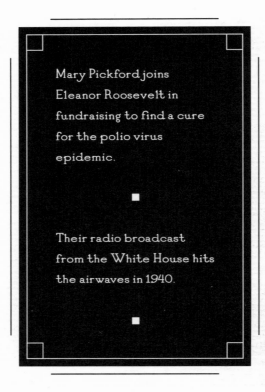

Mary Pickford joins
Eleanor Roosevelt in
fundraising to find a cure
for the polio virus
epidemic.

■

Their radio broadcast
from the White House hits
the airwaves in 1940.

■

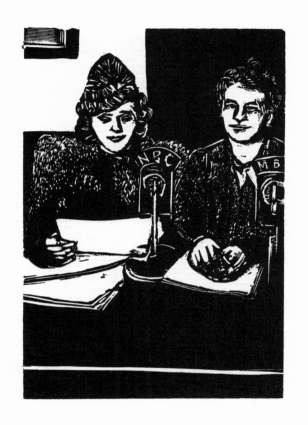

In 1942, Mary, along with
Jean Hersholt, breaks
ground at the future site
of the Motion Picture &
Television Country House
and Hospital, which will
become a fully licensed
acute care hospital.

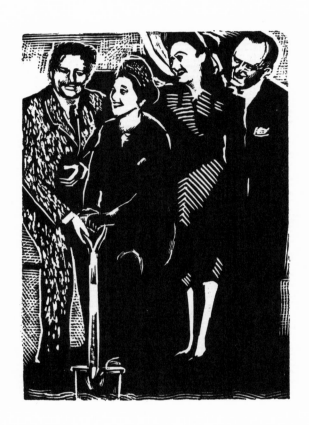

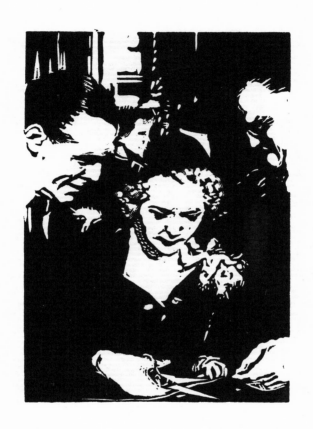

■

Mary and Buddy adopt
two children: a son, Ronald
Charles Pickford Rogers,
and a daughter, Roxanne
Pickford Rogers.

■

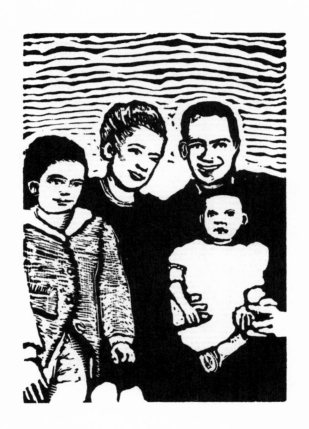

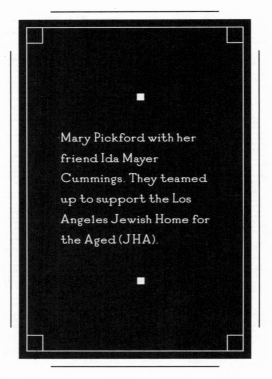

Mary Pickford with her friend Ida Mayer Cummings. They teamed up to support the Los Angeles Jewish Home for the Aged (JHA).

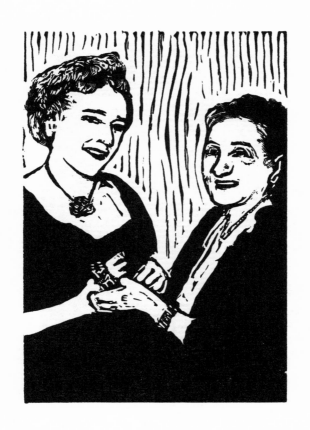

Mary presents the
Academy Award for Best
Picture to her friend and
colleague Cecil B.
DeMille at the 1953
Oscars ceremony.

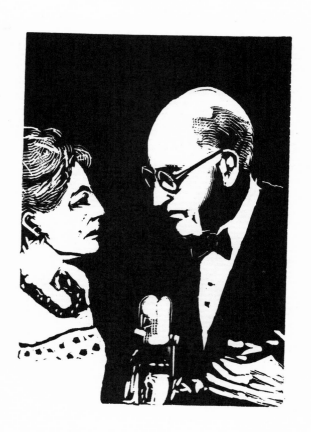

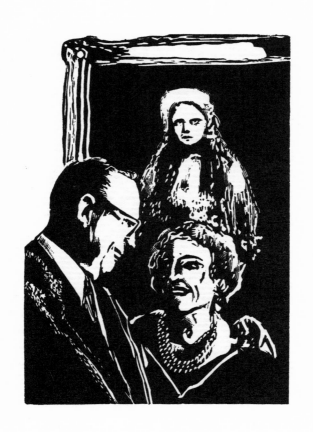

In 1956, Mary establishes
the Mary Pickford
Charitable Trust to
manage her philanthropic
endeavours.

Today it's known as the
Mary Pickford Foundation.

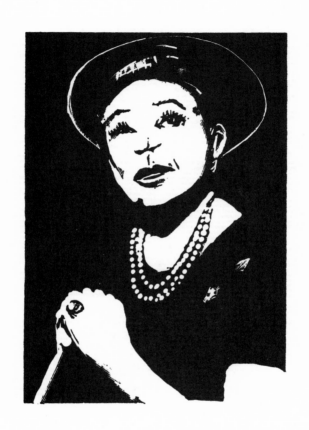

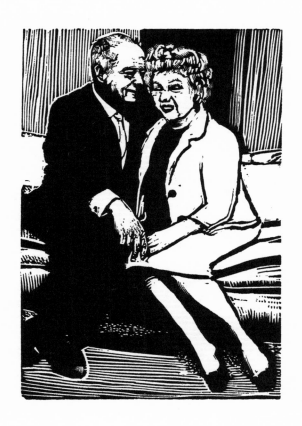

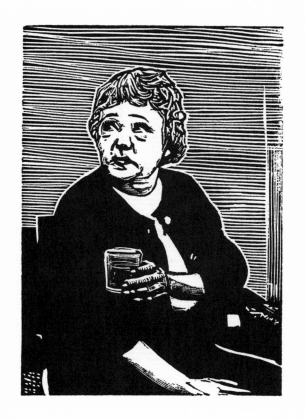

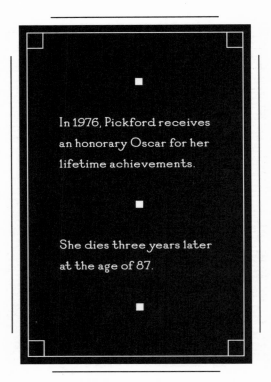

In 1976, Pickford receives
an honorary Oscar for her
lifetime achievements.

She dies three years later
at the age of 87.

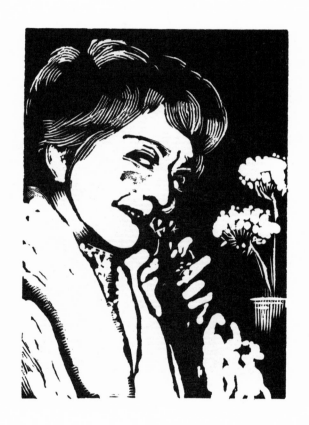

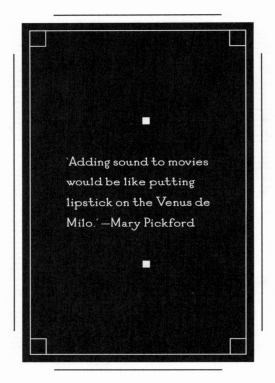

'Adding sound to movies would be like putting lipstick on the Venus de Milo.' —Mary Pickford

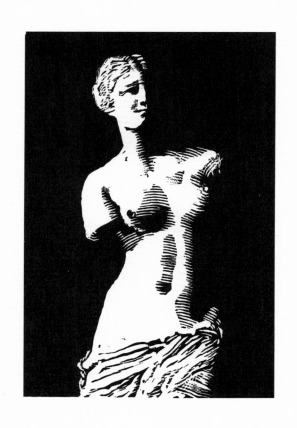

AFTERWORD

In the darkened cinema, our minds and our bodies cannot help but be spellbound by the creations of Mary Pickford. She is a grand manipulator of emotions and passions, and her characters incarnate from realities entirely different from our own. Certainly these characters exist in front of our eyes as projections on a screen, but as emanations, they come from—and commune with—some space deep inside us, one that is foundational to the human condition.

For the length of time we are immersed in this silent shadowland, time stands still. We watch, mesmerized by the ways in which black-and-white pictures can cast us instantly into another time, another dimension. The house lights come back up while the final credits roll. The light-borne illusions that moments ago flickered in front of our eyes fade away, replaced by the light of day.

Similarly, as we hold this book in our hands, turning its pages, we read an alphabet of experience. The words and pictures contained within are silent yet resonant symbols representing episodes in the life of an adventurous soul, an appealing figure, a powerful presence. When we close the cover of this book, its engravings leave traces of a mute visual story in our mind's eye—a paper-based analogue of the silent movie format. The message is the same in both art forms: Mary Pickford triumphed—in art and in life.

One common feature of Mary Pickford's movies and George A. Walker's engravings is their singular heroine. Though she played many roles, Pickford never completely disguised her true character. She was a person who, in her life and in her art, overcame loss, hardship and

formidable odds, recreating herself to embody eternal qualities of optimism and hope. Drawing from her life, she made a virtue of transmitting, in her various theatrical roles, a version of herself as an indomitable spirit, who, although beset by challenges both professional and personal, is never defeated. Pickford's life was therefore one of contrasts—of highlights and of shadows. She always strove to achieve the lightness of intelligent and creative accomplishment, overcoming the darkness of despair and fear of obscurity. Walker's engravings capture this essence of Pickford's biography, presenting in high relief episodes of her life.

This is the power of monochrome. The endlessly complex interactions of tones and tints in this narrow spectrum are hypnotic. They cast spells transporting us to domains populated by heroines and villains, to realms characterized by fear and loss, hardship and triumph, love and longing.

The wonder of Mary Pickford's and George A. Walker's palette is that it comprises just the one hue: black. This palette is adjusted either by the presence of light or by the absence of it. Pickford's mystical means of storytelling makes light itself her agent of self-expression. Through the technology of motion picture projection, sequences of single images, printed on celluloid, are animated by simply illuminating them from behind. Her theatrical tableaux are not much more than fluttering figments made from radiant light. Similarly, through the ancient arts of engraving, printing and binding, Walker's images are defined by the presence of black—and its absence. His pages contain shapes in ink and on paper, forms that coalesce in the mind's eye as readable elements of the larger sequence of events that constitute Pickford's life.

Whether interpreted in film or in print, the subject of Mary Pickford is as singular as she was herself, yet also as universal as humanity. Pickford taps the human heart by offering up to audiences versions of her personal story bathed in vulnerability and doubt, wrapped in cloaks of strength and frailty, and accorded with the

virtues of justice and truth. She crafts a fictional presence that reflects elements of her life story, but that presence is transformed by a pure and mystifying artistic alchemy. This is the source of her magical charm. We believe that her life and art are one and the same.

Triumphs and disappointments—hers and ours—are reflected in the tales of the invented heroines that Pickford portrays. The line between her creative fictions and her lived experiences is so indistinct that the actor disappears into her roles, dissolves into her art. Enraptured, we readily follow her, meeting her onstage as co-stars in an uncanny theatre, or on these pages as shadow players.

In the black-and-white sanctuary of the film or of the book, we acquiesce to these cunning artists' powers of transformation, to their ability to turn an actor into idealized characters we accept as eternally alive. Movie-born or paper-bound, these personae, illuminated by Mary Pickford's life, seize us in their enchanted grip. We embark on mute odysseys recorded onto celluloid and engraved into paper. These odysseys ring true for the time it takes us to view the art, and yet, films and engravings leave behind memories as ineffable as dreams and as fugitive as starlight. Upon leaving the cinema or closing this book, the ghost of these journeys lives on forever.

—Tom Smart

TOM SMART is a curator, essayist and gallery director, and an award-winning author of biographies, catalogues and art books on Canadian artists such as Christopher Pratt, Jack Chambers, Alex Colville and Mary Pratt. Currently executive director and CEO of the Beaverbrook, Smart has worked in art galleries and museums across Canada and the United States, among them the Frick in Pittsburgh, the Winnipeg Art Gallery and the McMichael Canadian Art Collection, where he was executive director from 2006 to 2010. Smart was also a distinguished visiting scholar at Pittsburgh's Carnegie Mellon University.

FVRTHER READING

Beauchamp, Cari. *Without Lying Down: Frances Marion and the Powerful Women on Early Hollywood*. New York: Scribner, 1997.

Brownlow, Kevin, and Robert Cushman. *Mary Pickford Rediscovered: Rare Pictures of a Hollywood Legend*. New York: Harry N. Abrams in association with the Academy of Motion Picture Arts and Sciences, 1999.

Fairbanks, Jr., Douglas. *Salad Days*. New York: Doubleday, 1988.

Goessel, Tracey. *The First King of Hollywood: The Life of Douglas Fairbanks*. Chicago: Chicago Review Press, 2016.

Harriman, Margaret, Case. *Take Them Up Tenderly, A Collection of Profiles*. New York: Alfred A. Knopf, 1944.

Herndon, Booton. *Mary Pickford and Douglas Fairbanks: The Most Popular Couple the World Has Ever Known*. New York: W. W. Norton, 1977.

Loos, Anita. *A Girl Like I*. New York: Viking Press, 1966.

Marion, Frances. *Off with Their Heads*. New York: Macmillan, 1972.

Pickford, Mary. *Sunshine and Shadow*. New York: Doubleday & Co, 1955.

St. Johns, Adela Rogers. *Love, Laughter and Tears: My Hollywood Story*. New York: Doubleday, 1978.

Whitfield, Eileen Pickford. *The Woman who Made Hollywood*. Lexington: University of Kentucky Press, 1997.

■

ACKNOWLEDGEMENTS

This project would not have been possible without the help of my friends and family. Thank you Michelle, my love, for all your support, encouragement and suggestions. Thanks to my brother-in-law Neil Exall for sending me books and finding articles to use in my research.

A debt of gratitude is also owed to my many editor friends who helped me through the textual parts of the project. They are, in alphabetical order: Dan Liebman, Martin Llewellyn, Stephanie Small, Chandra Wohleber and Michael Worek.

I would also like to extend my thanks to Mary Pickford Foundation Resident Scholar Cari Beauchamp, for writing the preface, fact-checking the intertitles and providing permission to excerpt portions of the Pickford Foundation's work in this project.

I am indebted to Susan Smart, whose cottage served as a comfortable studio in which to make many of the engravings in this book. I am likewise indebted to her husband, Tom Smart, for contributing the afterword. My thanks to both of them for their generosity and advice.

I am particularly grateful to Andy Malcolm in the making of this book. He lent a hand on the press, helped with contacts and handed me books as well as information on technical details about the history of filmmaking.

I wish to acknowledge the help provided by Warren Clements, pointing me to books and lending me a DVD of Pickford films.

Nick and Liana Howard were kind enough to invite me to print at their museum on the iron hand press and to use their Linotype machine.

A shout-out to Jeff Winch for daring to make a documentary film that features the wood writer of this humble book and for sharing his valuable knowledge about the history of filmmaking.

If I have forgotten anyone who may have lent me a book or pointed me to a resource, I am deeply sorry. Your contribution is appreciated here and your anonymity preserved.

■

OTHER BOOKS BY GEORGE A. WALKER
(available from the Porcupine's Quill / porcupinesquill.ca)

The Inverted Line
Images from the Neocerebellum
A Is for Alice
Book of Hours
The Mysterious Death of Tom Thomson
The Life and Times of Conrad Black
Trudeau: La Vie en Rose
The Hunting of the Snark